ECHOES OF LAUGHTER

An in-depth examination of the Multifaceted Life of Robin William

William B Drummond

Echoes of Laughter

An in-depth examination of the Multifaceted Life of Robin Williams

By

William B Drummond

All rights reserved. No part of this publication may be reproduced, distributed, or transmitted in any form or by any means, including photocopying, recording, or other electronic or mechanical methods, without the prior written permission of the publisher, except in the case of brief quotations embodied in critical reviews and certain other noncommercial uses permitted by copyright law.

Copyright © William B. Drummond, 2024.

Table of Contents

Preface...6
Introduction..9
Chapter 1.. 11
 Formative Years and Ancestry............................... 11
 Scholarship to Juilliard School and Official Education 15
 Career Beginnings and Influences.........................16
Chapter 2.. 18
 The Importance of Freestyle...................................18
 His Training at Juilliard School............................... 21
 "Mork & Mindy" Breakthrough, Robin Williams' Rise to Stardom... 24
Chapter 3.. 32
 Robin Williams' Path to Comedy Legend................ 32
 Robin Williams's Movie Debut and Early Roles......41
 Famous Early Roles... 49
 Robin Williams as a Voice Artist............................. 53
Chapter 4.. 57
 Relationships and Personal Life.............................. 57
 Being a Responsible Parenthood........................... 61
 His Relationships With his Friends......................... 63
 Individual Challenges and Achievements................65
 A Life Filled with Humanity, Love, and Laughter.....67
Chapter 5.. 70
 Battles with Addiction and Mental Health............... 70

 John Belushi's Death: A Tragic Wake-Up Call........ 71
 His Initial Moves Towards Recovery....................... 72
 Difficulties with Mental Health................................. 73
 Health Concerns and End-of-Life Challenges........ 74
 The Path to Advocacy and Recovery..................... 76

Chapter 6.. 81
 Robin Williams's Community Impact and Charitable Efforts... 81
 Persistent Impact on Upcoming Performer Generations.. 90
 The Final Years.. 94
 The Events Leading Up to Robin Williams' Untimely Death.. 94

Chapter 7.. 99
 Awards and Praise from Critics.............................. 99
 Collaborations and Professional Relationships.... 107
 Innovations and Contributions to Comedy............ 111
 His Moral Principles And Philosophy.................... 115

Chapter 8.. 120
 How Technology Has Affected His Career............ 120

Conclusions and Reflections................................. 123
 Moral and practical implications of Robin's Story. 125
 Filmography of Robin Williams.............................. 129

Preface

Ever since he first appeared on television as the quirky extraterrestrial Mork, Robin Williams has captivated our hearts with his distinct mix of warmth, comedy, and boundless energy. His performances have left a lasting impression on the entertainment industry and beyond throughout the years, making us laugh, weep, and ponder. However, underneath the insane personas and comic brilliance was a multifaceted, profoundly human person whose life narrative is just as captivating as any character he ever portrayed.

My goal in creating this biography has been to examine all of the many sides of Robin Williams: the entertainer, the friend, the family guy, and the person who battled personal issues while making millions of people happy. My quest has included several interviews, firsthand accounts, and a wide range of materials, all of which contribute to the

portrayal of a man who was as complex and nuanced as his most elaborate performances.

Investigating Robin's early life, I found that his upbringing—which was characterized by both affluence and seclusion—was the source of his humorous flare. His time at Juilliard demonstrated his unwavering brilliance and unrelenting dedication as he refined his art with future luminaries. Although his ascent to popularity was rapid, pressures and expectations accompanying it shaped—and even haunted—his career.

In addition to providing a chronological account of Robin Williams' life, the following chapters delve deeply into the factors that shaped his brilliance and the difficulties he encountered. With his iconic appearances in movies like "Dead Poets Society" and "Good Will Hunting," as well as his revolutionary work in stand-up comedy and television, this book

seeks to capture the spirit of a guy who could make people laugh and cry in equal measure.

The narrative of Robin is made up of successes and tragedy, light and dark, and happiness and sadness. We see the remarkable influence of a unique talent and the lasting legacy he left behind throughout his life. In addition to honoring Robin Williams' incredible career, my goal with this biography is to provide readers with a deeper understanding of the man who, in his own words, believed that laughter could illuminate the darkest corners of life.

I appreciate you coming along on this tour through the life of one of the greatest performers of all time.

Regards,

William B. Drummond

Introduction

We are grateful that you are joining us on this trip to discover the remarkable life of one of the most well-liked performers of our day. With his unmatched brilliance and complexity, Robin Williams was able to make us laugh and cry, leaving a lasting impression on our hearts and brains.Get ready to explore the worlds of a brilliant comedian, a talented actor, and a very real person as you flip these pages. We'll go from his early years, when he found humor to be a lifeline, to his quick ascent to stardom and the struggles he had on the personal front. This book attempts, even if it was difficult for him to do so himself, to convey the spirit of a guy who lived to make people smile via open interviews, personal tales, and critical analysis.

The tale of Robin is one of insight, sensitivity, and lasting influence. Regardless of your familiarity with his work, we hope this book adds to your

understanding of his extraordinary journey and offers fresh perspectives.

So take a seat, unwind, and let's honor Robin Williams' life—a genuine source of joy and light in a sometimes confusing world.

Savor the trip.

Chapter 1

Formative Years and Ancestry

The legendary comedian and actor Robin Williams came from a rich and diverse background that had a big impact on his career. Robin

McLaurin Williams was born in Chicago, Illinois, on July 21, 1951. His family had a variety of backgrounds and experiences, which helped to mold his distinct character and skill.

Early Family History

Robin Williams was raised by Laurie McLaurin, a former model and member of a well-known Mississippi family, while his father, Robert Fitzgerald Williams, was a senior executive at Ford Motor Company. Anselm J. McLaurin, a former Mississippi senator and governor, was Robin's paternal great-grandfather, demonstrating a prominent social and political background. Robin's upbringing, which combined elements of his mother's laid-back, socially prominent background with his father's corporate, regimented upbringing, gave him a distinct outlook on life.

His Early Years

As the youngest of three sons, Robin's father's successful job allowed him to grow up in a reasonably prosperous home. Robert's work required the Williams family to relocate often; they lived in Chicago, Detroit, and finally the wealthy environs of Marin County, California.

Robin often spoke about how lonely his early years were. Due to his hard work schedule, Robin's father was seldom home, and her mother was preoccupied with social events. As a result, Robin kept himself occupied by spending a lot of time alone. His creative and inventive side was ignited by this loneliness. In order to keep himself occupied, he would often make up voices and characters, which helped prepare him for a career in comedy and acting.

Schooling and Formative Impacts

The family moved around a lot, so Robin went to numerous different schools. His early schooling was

in public schools in the Midwest; however, he eventually attended private institutions, such as Detroit County Day School, where he wrestled and played soccer. His early discipline and work ethic were greatly influenced by these institutions' competitive atmosphere and focus on performance.

Robin's family relocated to Marin County, California, in the late 1960s, and he attended Redwood High School there. He kept doing sports there, especially wrestling, which he said was a way for him to release his pent-up energy. His comedic ability really started to show out in Redwood High School. The fact that his classmates chose him as "Funniest" and "Most Likely Not to Succeed" shows that they already saw his comic potential.

Following high school, Robin enrolled in the political science program at Claremont Men's College, which is now Claremont McKenna College. But he soon discovered his true interest

was somewhere else. He changed his studies to theater at the College of Marin. His father expressed some opposition to his desire to pursue acting, telling him to have a backup job and recommending welding.

Scholarship to Juilliard School and Official Education

When Robin was awarded a full scholarship to the renowned Juilliard School in New York City, it was his big break. He trained under renowned actor and director John Houseman from 1973 to 1976, who thought he had a lot of promise. Robin refined his art at Juilliard, expanding his knowledge of classical drama and honing his improvisational abilities.

His stay at Juilliard had a profound effect on him. He made a lasting connection with fellow actor Christopher Reeve that would have a significant influence on their respective careers. Robin's unbridled energy and inventiveness were

channeled into organized performances by his rigorous training at Juilliard, which paved the way for his success in both serious and comedic parts in the future.

Career Beginnings and Influences

Following his departure from Juilliard, Robin returned to California and began doing stand-up comedy in Los Angeles and the San Francisco Bay Area. His early performances were greatly impacted by the variety of humorous genres he met and the counterculture movement of the 1970s.

Robin mentioned a number of entertainers and comedians as inspirations, such as Peter Sellers, Richard Pryor, and Jonathan Winters. Because of his extraordinary improvisational skills and versatility, Winters in particular served as a major source of inspiration. Winters' approach was

mimicked by Robin with his quick-witted, exuberant delivery and versatility of identities.

Final Thoughts

Robin Williams's familial history and formative years were significant factors in the development of his comic gift. The regimented and competitive surroundings of his education, together with his early experiences of self-entertainment and loneliness, set the groundwork for his eventual success. His undeveloped gift was transformed into a potent force that enthralled audiences all around the globe by the guidance and instruction he got at Juilliard. By combining his many inspirations and life experiences, Robin was able to develop a distinct humorous style that connected with millions of people and had a lasting impression on the entertainment industry.

Chapter 2

The Importance of Freestyle

One of the most important turning points in Robin's career as a comic was when he discovered improvisational comedy. He was able to direct his intense energy and inventiveness into performances that were both unstructured and planned thanks to improvisation. His rapid thinking and spontaneous comedic timing became a distinctive characteristic of his technique.

Robin developed his interest in theater more deeply at the College of Marin, where she also received instruction in improvisational methods. His comic improvisational skills were evident in the many theatrical plays in which he took part. Audiences were enthralled by his frantic and unexpected energy throughout his performances.

Creating a Signature Look

Robin Williams' distinct comic approach combined his extraordinary improvisational skills, sharp wit, and vast repertoire of voices and characters. His ability to smoothly transition between identities was outstanding, resulting in a dynamic and surprising performance. He stood out from other comedians of his day because of this technique, which also helped him become a popular attraction in comedy clubs. His great energy and expressiveness were shown by the frequent use of physical comedy elements into his stand-up acts. Fans grew to love Robin because of his ability to interact with his audience and often include them in his performances, which fostered a feeling of closeness and connection. His performances were an experience, a laughing and feeling rollercoaster rather than merely a joke teller.

Early Broadcasting and Innovation

After being introduced in an episode of "Happy Days," Robin's big break came when he played the extraterrestrial character Mork in the television comedy "Mork & Mindy." The character was so successful that a spin-off show was created. "Mork & Mindy" provided Robin with an opportunity to display his improvisational skills and introduce his distinct comic style to a wider audience. The popularity of the program made Robin a household name and cemented his position in the entertainment business.

Robin Williams's early exposure to improvisation, school plays, and personal experiences all contributed to his discovery of humor. His lonely upbringing, which encouraged a vivid imagination, and his official schooling at Juilliard, which honed his innate skill, both contributed to the development of his distinctive style. Drawn to the colorful stand-up scene of the 1970s and the

comedy greats of his day, Robin's approach became dynamic and unexpected, captivating audiences. His early comedic career set the stage for an extraordinary career that would have a lasting impact on the entertainment industry.

His Training at Juilliard School

Juilliard offered rigorous voice instruction with an emphasis on articulation, projection, and the capacity to portray emotions vocally. The ability to produce a broad variety of personalities and voices—a talent that would become a hallmark of Robin's career—was greatly improved by this instruction. He gained stage presence by learning how to utilize his body on stage with movement lessons. This area of his study greatly enhanced Robin's expressive physical humor.

Although Robin's training was mostly classical, Juilliard also fostered his improvisational talent. The school gave him an opportunity to

demonstrate and hone his impromptu inventiveness because they understood its significance. Robin was given the opportunity to explore and push the limits of traditional humor via improvisation training and performances. His style began to be identified by this harmony between spontaneity and structure.

Order and Organization

Robin's natural inventiveness was enhanced by the structure and discipline that Juilliard taught him. He was forced to hone his abilities and expand his knowledge of performance art by the rigorous schedule and high standards. His rigorous devotion to his art, whether he was getting ready for a dramatic role or a stand-up act, demonstrated this discipline.

Versatility

Robin's extensive training at Juilliard contributed to his versatility as a performer. His ability to switch

between funny improvisation and Shakespearean monologues was impressive, since few performers could match his breadth of skills. His ability to thrive in a variety of positions and styles became a trademark of his career.

Difficulties and Development

Even while Robin did well at Juilliard, he had difficulties. The program's intensity and the competitive atmosphere could be intimidating. There were moments when Robin's distinctive technique ran counter to the more conventional methods taught at Juilliard. These difficulties, meanwhile, served as fire for his development, teaching him resiliency and how to incorporate all facets of his personality and skill into his performances.

The Juilliard Years' Legacy

Robin Williams had a life-changing experience at Juilliard. He was greatly influenced as a performer

by the instruction he got, the connections he made, and the experiences he experienced over those years. Juilliard gave him the means to direct his unbridled enthusiasm and inventiveness into performances that were both planned and unplanned.

In addition to his exceptional skill, his kindness and compassion are what left a lasting impact at Juilliard. He was a lifelong supporter of Juilliard, having spoken repeatedly about the influence of his time there. This formative era had a major impact on his career, as seen by his path from Juilliard to becoming one of the world's most beloved comedians.

"Mork & Mindy" Breakthrough, Robin Williams' Rise to Stardom

A turning point in Robin Williams' career was his breakthrough performance on the television program "Mork & Mindy", which launched him to

widespread recognition and solidified his status as a comic genius. This was the start of his transformation from an accomplished actor and stand-up comic to a cherished cultural figure.

Mork's Origins

A famous television series called "Happy Days" had an episode when the extraterrestrial creature Mork from the planet Ork was first presented. The February 28, 1978, episode, "My Favorite Orkan," was intended to be a lighthearted distraction starring an alien visitor who tries to return Richie Cunningham to his home planet for research.

The remarkable performance by Robin Williams was a major factor in the episode's popularity. His interpretation of Mork was extraordinarily animated and unmatched by anything previously seen on TV. Because of Williams' distinctive physical humor and improvisational abilities, the

character came to life and became an immediate crowd favorite.

Progress of 'Mork & Mindy" Development

"Happy Days" creator Garry Marshall saw the character's potential and Robin Williams's star power. As a result, "Mork & Mindy", a spin-off series, was rapidly established. The series, which took place in Boulder, Colorado, chronicled Mork's experiences as he attempted to comprehend human behavior and traditions, often with perceptive and amusing outcomes.

Williams was teamed with Pam Dawber, who portrayed the sensible young lady Mindy McConnell, who befriends Mork and guides him through Earthly existence. The success of the program was largely dependent on Williams and Dawber's chemistry. Dawber's composed depiction of Mindy served as the ideal counterpoint to Williams' wild and erratic Mork, resulting in a captivating and lively on-screen duo.

Effect and Acceptance

ABC debuted "Mork & Mindy" on September 14, 1978. With millions of viewers and strong ratings, the program became popular right away. The main event was Robin Williams' performance, which captivated spectators with his incredible improvisational skills and limitless energy. His depiction of Mork struck a chord with audiences of all ages with its fast-paced humor, physical comedy, and innocent curiosity.

Williams' ability to improvise was one of the show's highlights. He was given a lot of latitude by the producers to improvise, which resulted in some of the most memorable scenes in the show. His ability to improvise comedy and his openness to trying out various comic approaches distinguished "Mork & Mindy" from other comedies of the time. The program also addressed social and cultural topics from Mork's outsider viewpoint, offering funny but perceptive criticism. The show's success and critical

acclaim were facilitated by its unique combination of humor and social commentary.

Cultural Influence

"Mork & Mindy" soon rose to prominence in popular culture. Mork's catchphrases, such as "Shazbot" and "Nanu Nanu," became well-known. The character's unique outfit—which included rainbow suspenders and a red and silver space suit—became recognizable. Because of his role as Mork, Robin Williams became well-known, and his distinct style of humor had a lasting impact on popular culture.

TV comedy was greatly influenced by the popularity of "Mork & Mindy", which demonstrated the sitcom format's improvisational possibilities. Williams' performance demonstrated the value of originality and spontaneity in entertainment, inspiring a new generation of comedians and performers.

Honors and Accomplishments

Robin Williams won many honors and received worldwide praise for his work on "Mork & Mindy". In 1979, he was honored with a Golden Globe Award for Best Actor in a Television Series: Musical or Comedy in recognition of his exceptional work on the program. The show itself was further cemented in television history with several nominations and accolades.

Difficulties and Shifts

Even though "Mork & Mindy" was successful at first, there were problems in later seasons. A decrease in ratings was caused by modifications to the show's schedule and structure as well as shifting viewer preferences. New characters and storylines were added in an effort by the producers to revitalize the show, however reception to the changes was not unanimous.

The introduction of new characters, including Mindy's family and Orson, Mork's supervisor on Orkan, was one of the major alterations. Although these additions opened them additional comedy possibilities, they sometimes upset Mork and Mindy's established chemistry. Furthermore, viewers did not always embrace changes in the show's direction and tone.

Career After "Mork & Mindy"
After "Mork & Mindy" ended, Robin Williams made the move to the big screen, where his distinct brand of humor and emotion never failed to enthrall viewers. His cinematic career included enduring parts in films like "Dead Poets Society", "Good Morning, Vietnam", and in "Good Will Hunting", which won him an Academy Award for Best Supporting Actor.

Williams' tenure on "Mork & Mindy" contributed to his widespread popularity in pop culture. He

continued to be a well-liked stand-up comedian, a regular guest on discussion programs on television, and a significant figure in the entertainment industry. Regardless of the media, his ability to engage viewers highlighted his extraordinary skill and timeless appeal.

Final Thoughts

A pivotal point in Robin Williams' career was his breakout performance in *Mork & Mindy*, which demonstrated his improvisational prowess and made him a comic heavyweight. In addition to making him famous throughout the country, the series had a long-lasting effect on television humor. Williams' legendary performance as Mork showcases his incredible ability and inventiveness. His performance on *Mork & Mindy* set the stage for a fantastic career that would make millions of people happy and laugh, solidifying his status as one of the most adored performers of all time.

Chapter 3

Robin Williams' Path to Comedy Legend

Robin Williams' extraordinary brilliance, unwavering energy, and ground-breaking improvisational abilities all contributed to his

meteoric climb to fame in stand-up comedy. He is one of the most important comedians of his age because of his distinct style and audience-connecting skills, which help him stand out in the cutthroat comedy industry. This in-depth examination covers his early attempts at stand-up, his growth as a performer, and his ongoing influence on the comedy scene.

The Initial Steps Into Stand-Up
Early in the 1970s, Robin Williams made his debut in the stand-up comedy scene in San Francisco, a city renowned for its thriving and diverse cultural community. Following his departure from Juilliard in 1976, Robin went back to California and became deeply involved in the local comedy clubs. San Francisco's progressive climate and counterculture gave him an ideal environment to develop his comic skills.

Holy City Zoo and Additional Locations

The Holy City Zoo, a little but venerable comedy club in San Francisco, was among the first places where Robin gave frequent performances. Robin found that the Holy City Zoo was an invaluable place to practice his content and hone his humorous accent. His exuberant, lightning-fast delivery and fluid improvisation were hallmarks of his club appearances.

Apart from the Holy City Zoo, Robin showcased her comedic skills in renowned establishments like the Great American Music Hall and the Boarding House. These venues were well-known for showcasing up-and-coming comic talents, and they gave Robin the platform he needed to develop a fan base.

Innovation and Style Evolution
Stream-of-consciousness style and frantic energy characterized Robin's early stand-up performances, setting him apart from his peers. His inspiration came from a variety of places, such as classical

theater, improvisational comedy, and the countercultural movements of the 1960s and 1970s. His comedic style often blended physical humor with voice impersonation to express critical reflections on politics, society, and human nature.

Intelligent Empathy
Robin had unmatched improvising abilities. His ability to improvise comedy came from his observations of his surroundings, the responses of the audience, and the news of the day. Because of his skill at improvisation, he was able to make his performances interesting and surprising, which won over audiences who were never sure what to anticipate.

One of his greatest stylistic traits was his ability to transition between voices and characters with ease. Whether he was playing a Russian immigrant, a quirky elderly lady, or a Scottish golfer, Robin's expressive body language and vocal range effectively

brought his roles to life. His unique style of humor demonstrated his flexibility as a performer and set him apart.

Ascent to Notoriety

When Robin Williams made appearances on the comedy series "Make Me Laugh" and the television program "An Evening at the Improv", it was his big break in stand-up comedy. His portrayal of Mork on "Happy Days", which later branched out into "Mork & Mindy", which became his first significant television role and helped him get more recognition from the public thanks to his performances in these series.

Even after becoming well-known thanks to "Mork & Mindy", Robin kept up his stand-up routine throughout his career, consistently improving and venturing into new comedy realms.

Events and Legendary Performances on HBO

Through many HBO specials in the 1980s, Robin Williams cemented his reputation as a comedic icon. A nationwide audience was exposed to Robin Williams' distinct style and improvisational prowess via these specials, which included "Off the Wall" (1978), "An Evening with Robin Williams" (1982), "Robin Williams: Live at the Met" (1986), and "Robin Williams: Live on Broadway" (2002).

"Robin Williams: Live at the Met" stands out especially for its exuberant performance and perceptive, often moving, comments on current affairs. Williams' reputation as a comic who could make audiences laugh while making them think was cemented by his ability to combine comedy with deeper sociological concerns.

The environment around Robin and his own experiences had a big impact on his humor. His personal experiences with drugs, relationships, and the absurdities of celebrity were among the many

sources of inspiration. Audiences responded favorably to his candor and vulnerability regarding his struggles, which gave his humor more nuance.

Williams was skilled at utilizing comedy to make social and political commentary and had a sharp sense of sarcasm. He often delivered scathing criticism of politicians, social mores, and contemporary culture throughout his concerts. This particular facet of his humor demonstrated his profound comprehension of human nature and his capacity to find laughter in the most somber circumstances.

The fact that Robin had a background in physical theater and mime was another important impact on his comedic style. Under the famous teacher Claude Kipnis, he learned mime, and he used these skills in his performances. His exaggerated motions, expressive gestures, and amazing ability to change his body to match many personalities and situations were hallmarks of his physical humor.

Difficulties and Development

Throughout his career, Robin Williams had several difficulties despite his success. His battles with addiction were well known, and he often turned to humor to help him deal with his inner demons. His mental health suffered as a result of his career's unrelenting speed and the demands of celebrity.

It was harder for Robin to manage stand-up with his acting responsibilities as his film career took off. He often returned to the stage in between film endeavors, however, staying true to his comedic origins. His ability to connect with people was still strong, and his live performances continued to attract sizable crowds. Over time, Robin's humor changed to reflect shifting audience expectations and cultural conventions. By regularly revising his material and adopting new humorous methods, he managed to stay current. His ability to stay relevant and perceptive was evident in his latter stand-up

acts, which often contained observations on aging, technology, and the changing political scene.

Attribution to Other Comedians

Robin Williams is credited by several comedians as having had a major effect on their work. His daring, inventiveness, and capacity to push the comic envelope made him an inspiration to a new generation of actors. Comedians who have discussed the influence Williams had on their careers include Sarah Silverman, Eddie Murphy, and Jim Carrey.

In Conclusion, Robin Williams' remarkable skill, unwavering enthusiasm, and innovative approach were hallmarks of his stand-up comedy career. Williams is regarded as one of the greatest comedians of all time because of his ability to engage audiences via humor and improvisation, which he demonstrated in both his early comedic roles in San Francisco's comedy clubs and his legendary HBO specials. His effect on other

comedians, his ability to combine humor with social criticism in a unique way, and his lasting influence on the entertainment industry define his legacy in stand-up comedy.

Robin Williams's Movie Debut and Early Roles

A new phase in Robin Williams' remarkable career began when he moved from stand-up comedy and television to the big screen. His early cinematic roles demonstrated his flexibility and laid the groundwork for a multi-decade career including a wide range of characters. This thorough examination examines Robin Williams's first cinematic venture, his noteworthy early parts, and the reviews he received for them.

Shift to Cinema

With the popularity of 'Mork & Mindy", Robin Williams decided to take a chance on the film

industry to broaden his creative horizons. Even though he was already well-known for being a talented comic and television personality, the switch to cinema provided fresh chances to develop other aspects of his skill. Though there were difficulties along the way, Williams' natural talent for combining comedy and depth of feeling made him a highly sought-after actor in Hollywood very soon. The following are the numerous movies he has featured in over the years;

A

First Film Role: 1980's "Popeye".

In the titular character in Robert Altman's live-action version of the well-known comic strip and animated series, "Popeye", Robin Williams made his screen debut. In the 1980 release, Williams played the well-known spinach-eating sailor, a part that gave him the chance to showcase his range of voice tones and physical humor abilities.

Williams' dedication to emulating Popeye's distinct speech patterns and mannerisms was evident in his depiction of the character. His portrayal of Popeye, which required considerable makeup and outfit changes, was a tribute to his commitment. Critics gave "Popeye" varying reviews, although Williams' performance was largely commended for its sincerity and intensity. The movie's box office success contributed to Williams's rise to prominence as a leading man in the motion picture business.

B

The World According to Garp: An Early Dramatic Role (1982).

After "Popeye", Robin Williams portrayed a more dramatic character in George Roy Hill's John Irving adaption, "The World According to Garp". Williams played T.S. in the 1982 motion picture release. Garp is a writer who manages the difficulties of relationships and life.

Unlike his prior humorous parts, Williams' depiction of Garp demonstrated his ability to handle tragic material. His portrayal of the character's progress and challenges was subtle and sincere. Williams' emotional range and depth won him praise from critics who saw beyond his humorous abilities. The movie's critical acclaim enhanced Williams' standing as a versatile actor who can handle challenging parts.

C

"Moscow on the Hudson" (1984): A breakthrough role.

Paul Mazursky's 1984 film "Moscow on the Hudson" stars Robin Williams. The film chronicles the tale of Soviet circus musician Vladimir Ivanoff, who, while performing in New York City, defected to the United States. Williams was able to investigate questions of identity, independence, and cultural adaptability in this position.

Williams' depiction of Vladimir demonstrated his ability to combine comedy with nuanced emotional depth by being both humorous and tragic. To guarantee a genuine portrayal, he studied the Russian language and culture for months before taking on the part, in addition to learning how to play the saxophone. Williams' commitment and adaptability were lauded by critics, who saw "Moscow on the Hudson" as a turning point in his career. The movie's success proved that Williams

could direct a picture and manage characters that were nuanced and multifaceted.

D

"Good Morning, Vietnam" (1987): Determining His Scope.

Robin Williams's 1987 film *Good Morning, Vietnam*, starring Adrian Cronauer, was one of his most important early performances. Based on the experiences of an actual Armed Forces Radio Service DJ, the comedy-drama film gave Williams the ideal stage on which to display his whole skill set. Williams' portrayal of Cronauer was riveting; it was marked by dramatic, heartfelt moments that captured the reality of the Vietnam War and fast-paced, improvised humor during the radio parts. He received a lot of praise for his ability to switch between comedy and serious criticism with ease. Williams was nominated for his first Academy Award as Best Actor for the performance, and he was awarded a Golden Globe for Best Actor in a

Comedy or Musical Picture. *Good Morning, Vietnam* established Williams as a prominent Hollywood actor and was a critical and financial triumph.

E

In 1989, he expanded his dramatic range with "Dead Poets Society".

Robin Williams, who was still developing as a serious actor, was featured in Peter Weir's "Dead Poets Society" (1989). Williams portrayed John Keating, a unique English instructor at a traditional boys' prep school who encourages his pupils to appreciate poetry and live each day to the fullest ("Carpe Diem"). Williams' depiction of Keating demonstrated his ability to subtly and inspirationally communicate great emotion. Williams' performance was highly acclaimed for its authenticity and depth, and the picture was met with critical acclaim. A generation was impacted by

"Dead Poets Society", which also earned Williams a second Academy Award nomination for Best Actor. The film became a cultural landmark. The success of the movie enhanced his standing as a performer who can provide strong dramatic performances.

F

First Comedic Achievement: "Mrs. Doubtfire" (1993).

Robin Williams kept juggling tragic and humorous parts in the early 1990s. "Mrs. Doubtfire" was one of his most notable early comedy achievements. Chris Columbus directed "Mrs. Doubtfire" (1993). Williams portrayed Daniel Hillard, an actor fresh off the divorce train who poses as an old British nanny to spend time with his kids.
Williams's portrayal of "Mrs. Doubtfire". A masterwork of humor, physical metamorphosis, and genuine emotion was Doubtfire*. His flexibility and comic brilliance were on full display when he

switched between the roles of Mrs. Doubtfire and Daniel. Williams' performance in the movie earned rave reviews and helped make the movie a huge financial success. It was one of the pivotal roles in his career and brought him a Golden Globe for Best Actor in a Motion Picture Musical or Comedy.

Famous Early Roles

Robin Williams played several parts in the late 1980s and early 1990s that showed his versatility in a range of genres and character types. Among the noteworthy early roles are:

1.) The 1991 film The Fisher King
Williams portrayed Parry, a homeless man searching for the Holy Grail in contemporary New York City, in Terry Gilliam's *The Fisher King*. His portrayal, which combined humor and sorrow, won him praise from critics and led to his third Academy Award nomination for Best Actor.

2.) Awakenings (1990)

Williams co-starred with Robert De Niro as Dr. Malcolm Sayer, a doctor who treats patients who are catatonic, in Penny Marshall's *Awakenings*. He was praised for his nuanced performance because of his controlled and empathic depiction, which demonstrated his ability to handle serious and delicate material.

3.) Hook (1991)

Williams played the well-known part of Peter Pan in Steven Spielberg's 'Hook', a man who has grown up and forgotten his magical background. Williams' charisma and ability to captivate audiences of all ages were on full display as he explored themes of youth, creativity, and adventure in the movie.

4.) The Hunt for GoodWill (1997)

Williams' portrayal of Dr. Sean Maguire in *Good Will Hunting* is among his most well-known dramatic performances. The film, which was

written and directed by Gus Van Sant, stars Matt Damon and Ben Affleck and tells the tale of Will Hunting, a teenage math prodigy, and his therapy session with Dr. Maguire.

He did a touching and sympathetic job as Dr. Maguire. His character's wisdom and sensitivity served as a counterpoint to Will's turbulent journey, and their encounters formed the film's central emotional heart. Williams's achievement solidified his reputation as a drama mastermind and won him the Academy Award for Best Supporting Actor.

5.)Hourly Snapshot (2002)
Williams portrayed Seymour "Sy" Parrish in Mark Romanek's "One Hour Photo", a film about a lone photo technician who becomes fixated on a family whose images he processes. Williams's psychological thriller gave him the chance to delve into more sinister facets of human nature. Williams gave a spooky and unsettling performance as Sy. In contrast to his typical performances, he was able to

capture the character's loneliness and spiral into obsession, demonstrating his variety and adaptability. Williams was commended by critics for his eerie and captivating performance, underscoring his aptitude for deeper, more nuanced parts.

Final Thoughts

Robin Williams's remarkable range and skill were emphasized by his early performances and his crossover to the film industry. From "Popeye" to "Good Morning, Vietnam" and "Dead Poets Society", Williams made a significant impression by showcasing an unmatched ability to combine comedy and emotional depth. His performances in these early motion pictures made him a household name in Hollywood and paved the way for a career filled with a variety of noteworthy and influential roles. His status as one of the most gifted and well-liked performers of his time was cemented by the positive reviews given to his early performances.

Robin Williams as a Voice Artist

When it came to voice acting, Robin Williams' skill set went beyond live-action roles. He was able to breathe life into some of the most iconic animated characters in movie history. His vivacious personality, limitless vitality, and spontaneous abilities rendered his animated characters. However, Robin Williams played a crucial role in the following animation movies;

1.)Aladdin (1992): Williams's most well-known voice acting part was in Disney's *Aladdin* as the Genie. Williams' portrayal had a major role in the animation industry's milestone status for the Ron Clements and John Musker-directed picture. Williams brought his signature comedy, quick wit, and limitless energy to the role of the Genie. He was able to construct a persona that was charming and entertaining because of his improvisational talents.

Williams won a special Golden Globe Award for the performance, which was a critical and financial hit and cemented Genie's status as one of the most adored animated characters ever.

2.) The Last Rainforest: FernGully (1992):

Williams provided the voice of Batty Koda in "FernGully: The Last Rainforest", a peculiar and humorous bat who helps the main characters in their effort to save the rainforest. His performance gave the movie a heartfelt and humorous touch.

Williams' zaniness and charm were hallmarks of his voice acting as Batty Koda. He received a lot of appreciation for his vocal performance, which helped the film's appeal and environmental message by bringing the character to life.

3.)Mechanics, 2005: Williams portrayed the humorous and rambunctious robot Fender in the animated feature *Robots*, which was directed by Chris Wedge and Carlos Saldanha. His act gave the ensemble cast of the movie more fun and energy. Williams embodied the same enthusiasm and improvisational mastery in his depiction of Fender. One of the best parts of the movie was how he brought personality and comedy to the role, and for that, he was praised for his work on the animated picture.

In Conclusion, the trajectory of Robin Williams' career bears witness to his exceptional aptitude and adaptability. His voice acting brought cartoon characters to life in ways that pleased audiences of all ages, while his serious parts demonstrated his emotional depth and ability to express complicated characters. Williams was one of the most adored and esteemed performers of his day because of his ability to cross genres and combine comedy with

intense emotion. His reputation as a genre-transcender, master of drama, and virtuoso voice actor ensures that his contributions to the entertainment industry will be cherished for many years to come.

Chapter 4

Relationships and Personal Life

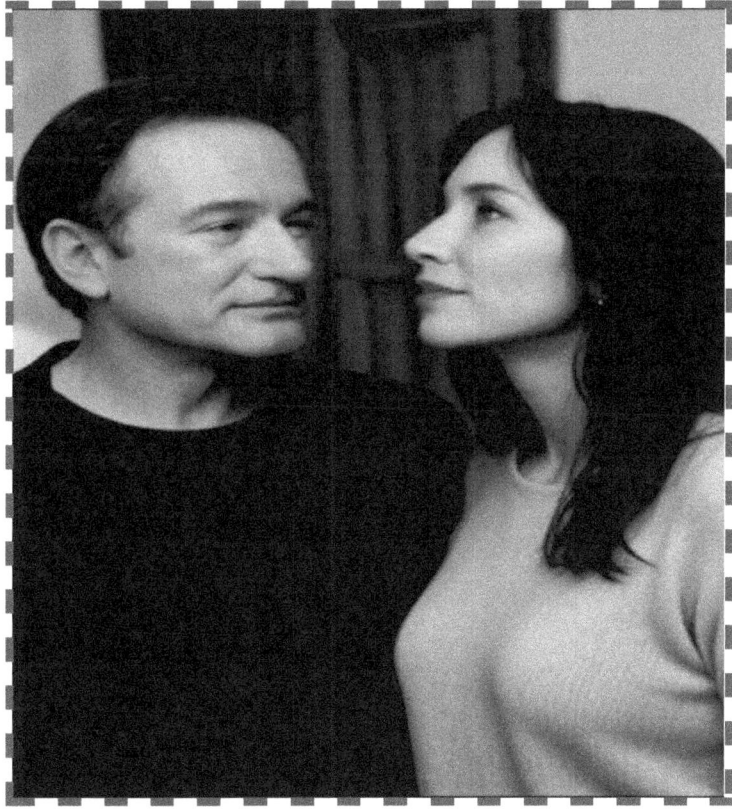

Robin Williams, well-known for his broad range of performing roles and sense of humor, has a personal

life full of meaningful friendships, profound loves, and close connections. This thorough examination digs into his fatherhood experiences, marriages, and the friendships that influenced his life.

Matrimonials and Amorous Bonds
In his private life, Robin Williams had three marriages, all of which were characterized by development, love, and difficulties. These connections were essential to his life since they offered him friendship and support during difficult times.

<u>Valerie Velardi, 1978–1988: First Marriage</u>
In 1978, dancer and actress Valerie Velardi wed Robin Williams. Midway through the 1970s, while Williams was still starting his comedic career, they met in San Francisco. Their love started in the heart of the city's thriving creative scene.

Coexistence and Difficulties

Williams' career took off with "Mork & Mindy" during their marriage, bringing with it additional demands in addition to fame. Zachary Pym "Zak" Williams, the couple's only child, was born in 1983. There was tension in their relationship due to Williams's increasing success and the expectations of fame. Williams's work responsibilities and personal issues, including his drug misuse, caused them to divorce in 1988, despite their love for one another.

Marsha Garces, 1989–2010: Second Marriage

Robin wed Marsha Garces a second time; she had been Zak's babysitter at first. Shortly after Zelda Rae Williams, their first child together was born, they were married in 1989. Afterward, Marsha turned to producing and working on several Williams movies.

Workplace Collaboration and Family Life

Cody Alan (born 1991) and Zelda Rae (born 1989) were Marsha and Robin's two children. Their marriage brought together their personal and professional lives, with Marsha producing several Robin-starring movies, such as *Mrs. *Patch Adams* and Doubtfire*. Their partnership had difficulties despite their mutual triumphs, which led to their separation and divorce in 2010.

Susan Schneider, Third Marriage (2011–2014)

In 2011, Robin Williams married a graphic designer Susan Schneider. They bonded soon after meeting in 2011. In Williams' final years, Susan was a reassuring presence, helping him through several health issues.

Health Concerns and Assistance

Williams had serious health issues throughout their marriage, such as an open heart surgery in 2009 and

a Parkinson's disease diagnosis that was subsequently determined to be Lewy body dementia. Susan provided him with steadfast support throughout these trying times. They were married until Williams' untimely death in 2014.

Being a Responsible Parenthood

Being a parent was something Robin Williams valued. He took great pleasure and satisfaction in his ties with his three children, Zach, Zelda, and Cody.

1.)Zak Williams

Born in 1983, during Robin's first marriage, Zak Williams had a strong relationship with his father. Zak overcame the difficulties of having a well-known dad, going on to forge his career and become an entrepreneur and mental health champion. Zak has devoted a significant portion of his life to mental health advocacy, spreading knowledge about mental health concerns and

backing programs that assist people in need, having been inspired by his father's candor about his challenges.

2.)Zelda Williams

Zelda Rae Williams is an actor and director who was born in 1989. She was named after the Princess Zelda figure from video games, and she had a close bond with her father, who often supported her artistic endeavors.Zelda has taken on a variety of roles in television and movies, carrying on her father's history in the entertainment business. In addition, she has honored her father's legacy by speaking out about the impact he had on both her personal and professional lives.

3.)Cody Williams

The youngest of Robin's children was born in 1991 and is known as Cody Alan Williams. Cody, who keeps a low profile compared to his brothers, has sought a career in the film business behind the

scenes. Cody continues to be close to his family and pays tribute to his father in his unique manner via his job in film production, which showcases his enthusiasm for the creative process.

His Relationships With his Friends

Throughout his career, Robin Williams' connections served as a pillar of support and affection in his personal life. Among his pals were performers, comedians, and business associates who valued his good nature, generosity, and sense of humor. We shall delve into his friends names below;

1.)Jonathan Winters

Williams regarded comedian Jonathan Winters as a mentor and a big influence on his humorous approach, making him one of his closest friends. Their mutual appreciation of humor and improvisation brought the two closer together.

Inspiration and Mentoring

Williams was greatly influenced by Winters, who shaped his sense of humor and improvisation. Mutual respect and affection characterized their connection, with Williams often referring to Winters as his comedy hero.

2.)Crystal Billy

Over many years, Williams and Billy Crystal had a strong bond. Their friendship was clear from their joint ventures and public appearances, such as their amazing work on the television charity series Comic Relief.

Serious Solace and Human Connections

Their camaraderie was defined by laughter and support for one another. Speaking of their close relationship and the influence Williams had on his life, Crystal was among the first to express her grief at Williams' demise in public.

3.) Whoopi Goldberg

Whoopi Goldberg was another close friend and colleague. The three co-hosted *Comic Relief* shows with Crystal, generating millions of dollars for the homeless. Their connection, characterized by sincere regard and respect for one another, went beyond working together professionally.

Working Together and Developing Friendships

Williams and Goldberg have a close friendship as well as mutual professional respect. She has spoken extensively about Williams' kindness and the significant influence he had on her life and career.

Individual Challenges and Achievements

Robin Williams had many personal difficulties despite his achievements, such as troubles with addiction and mental health concerns. His candor regarding these difficulties won him over to many, demonstrating his strength and compassion.

A) Fights Addiction

Williams's history of drug misuse was well reported. In the early 1980s, he struggled with cocaine and alcohol addiction before becoming sober. In the early 2000s, he had a relapse, but he sought help and kept talking candidly about his path to recovery.

Action and Impact

Williams' openness about his experiences with addiction de-stigmatized these problems and motivated others going through similar hardships. His readiness to confront his issues in public demonstrated his dedication to assisting others.

B.) Lewy Body Dementia and Mental Health

Williams had severe mental health issues in the years before his death, which were made worse by the advent of Lewy body dementia, a

neurodegenerative disease that alters behavior and cognitive function.

Initially misdiagnosed as Parkinson's disease, the diagnosis presented several difficulties. Williams had severe anxiety, sadness, and hallucinations as a result of his Lewy body dementia. His bravery in overcoming these obstacles, even in the last few months of his life, demonstrated his fortitude and fortitude.

A Life Filled with Humanity, Love, and Laughter

The legacy of Robin Williams is one of deep empathy, love, and humor. His interpersonal and professional interactions were characterized by sincere compassion and strong bonds. Williams had a profound impact on many people's lives as a husband, father, and friend. His legacy is still uplifting and inspiring today.

Persistent Impact

Williams' impact goes beyond his comedies and movies. The world will never be the same because of his willingness to share his hardships, his unwavering devotion to his friends and family, and his unwavering commitment to helping others.

Remembrances and Tributes

Tributes to Williams, who passed away in 2014, came in from all around the globe, demonstrating the profound influence he had on a great number of people. In recognition of the happiness and inspiration he offered to the world, his family, friends, and admirers are still celebrating his memory today.

Final Thoughts

A complex tapestry of connections, deep love, long friendships, and significant hardships characterized Robin Williams' personal life. The guy behind the iconic performances was greatly influenced by his marriages, his experiences as a parent, and the

friendships he developed. Williams has left a lasting legacy that continues to inspire and impact individuals all over the globe because of his unending compassion and humanity, as well as his ability to overcome personal issues with fortitude and honesty.

Chapter 5

Battles with Addiction and Mental Health

Millions of people adored actor and comedian Robin Williams for his candor about his troubles in addition to his extraordinary skill. Williams struggled greatly with addiction and mental health problems throughout his life. His road to recovery was characterized by fortitude, candor, and a persistent desire to get support and encourage others going through comparable struggles.

1.) Abuse of Alcohol and Cocaine: Williams first experienced addiction in the late 1970s and early 1980s. He started abusing cocaine and alcohol while his career with "Mork & Mindy" was at its peak. His drug usage was exacerbated by the hectic pace of his profession and the demands of his unexpected popularity.

2.) **The Scene in Hollywood:** Williams was a member of the Hollywood culture that was notorious for its widespread drug usage in the late 1970s and early 1980s. He often went out on the town with other performers and comedians, many of whom had drug issues. Williams subsequently explained his heavy drug and alcohol use at this time as a coping mechanism for the demands and expectations of his quickly developing profession.

John Belushi's Death: A Tragic Wake-Up Call

Williams's life took a dramatic turn in 1982 when his close friend and fellow comedian John Belushi passed away from a heroin overdose. He was astonished and emotionally saddened by the fact that he had spent only a few hours with Belushi before his death. This terrible incident acted as a wake-up call for Williams, who decided to reassess his own life and drug addiction.

His Initial Moves Towards Recovery

After Belushi passed away, Williams consciously chose to sober up. Zachary, his first son, was born in 1983, which gave him even more incentive to alter his way of life. He committed to recovery and gave up **alcohol** and **narcotics** more than 20 years ago.

Support Systems

Williams sought the support of his close friends and family throughout his early recovery journey. Valerie Velardi, his first wife, was a major factor in his ability to maintain sobriety. Williams also reached out to the larger recovery community and other recovery programs, realizing how important it was to surround himself with others who could relate to his challenges.

Difficulties with Mental Health

3) Depression Struggles: Williams struggled with sadness constantly, and his drug problems were often entangled with it. Though he presented himself to the world as a lively and upbeat comic, in private he struggled with deep emotional issues. Williams was candid while discussing his sadness and said that it was a never-ending struggle. His everyday life and work were greatly impacted by his despair. Williams sometimes found it difficult to work or interact with others. He persisted in his efforts despite these obstacles, often utilizing his job as a kind of therapy and a means of controlling his symptoms.

4) Bipolar Disorder and Anxiety: Williams suffered from anxiety as well as depression, and it was thought that he had bipolar disorder symptoms. This illness was evident in his abrupt mood swings and powerful bursts of high energy

interspersed with bouts of profound depression. Williams' drug problems were often made worse by his mental health problems, which led to a vicious cycle that was hard to escape.

Health Concerns and End-of-Life Challenges

5.) Heart Surgery Open: Williams had open heart surgery to replace an aortic valve in 2009. Both physically and psychologically taxing was the procedure and the healing that followed. Williams then discussed how this significant medical incident affected his mental state, pointing out that it exacerbated emotions of worry and vulnerability.

6) Positive Disease Diagnosis: Williams was identified as having Parkinson's disease in the months before his death. Parkinson's disease is a neurological illness that impairs movement and may

result in tremors, stiffness, and issues with balance and coordination. Williams carried a lot of weight with his diagnosis, which he first kept confidential.

Symptoms and Effects

Williams's capacity to function was impacted by the tremors and movement difficulties associated with Parkinson's disease. These physical difficulties exacerbated his continuing struggles with anxiety and sadness, creating a perfect storm of mental and physical health problems.

7) Dementia of Lewy Bodies: It was discovered after Williams passed away that he had Lewy body dementia, a disorder that is often misdiagnosed as Parkinson's disease. Cognitive deterioration, visual hallucinations, and extreme mood swings are the hallmarks of Lewy body dementia. Williams' anxiety and sadness were probably made worse by this illness, which made it harder for him to cope in his last few months.

The Path to Advocacy and Recovery

Dedication to Recovery

Williams persisted in his commitment to his healing process despite his difficulties. He often went to therapists, support groups, and rehabilitation facilities for assistance. His willingness to ask for assistance and be transparent about his struggles inspired many.

Public Speaking and Advocacy

He took advantage of his position to promote addiction treatment and mental health awareness. By being open and honest about his own experiences, he helped lessen the stigma attached to these problems. He supported mental health groups, took part in charitable activities, and used his public appearances to advocate for the value of getting assistance.

A Effect on Public View

Williams' candor regarding his difficulties had a significant influence on how the general public viewed mental health and addiction. By sharing his own story, he made others feel less alone and more confident to ask for assistance when they needed it. His contributions to this field have inspired and motivated others to advocate for mental health and addiction treatment.

Family and friend support

Williams's family and friends gave him a lot of support throughout his travels. His third wife, Susan Schneider, and his second wife, Marsha Garces, played a crucial role in assisting him in overcoming his health issues. Whoopi Goldberg and Billy Crystal were among the friends who offered understanding and emotional support.

Care Network

Williams had therapists, other members of the recovery community, and medical experts as part of his support system in addition to his family. This network was a lifeline at his darkest moments, aiding in the management of his addiction and mental health problems.

Legacy and Significance

In the fields of addiction treatment and mental health, Robin Williams' impact endures and inspires. His desire to be transparent about his difficulties has had a long-lasting effect on how society perceives these problems. Williams' experience serves as a poignant reminder of the need for empathy, understanding, and support for those going through comparable struggles.

Awards and Tributes

Tributes to Williams, who passed away in 2014, came from all across the globe, showcasing not only

his extraordinary ability but also his courage in facing his struggles. Through a variety of efforts, including funding for drug treatment programs and mental health awareness campaigns, friends, family, and fans have continued to commemorate his legacy.

Advocacy and Foundation Work

Following his death, the Williams family and close friends carried on his advocacy work by assisting organizations that promote addiction treatment and mental health. Through these initiatives, Williams' legacy of kindness and encouragement to those facing comparable challenges is preserved.

In addition to having tremendous skill, Robin Williams struggled greatly with addiction and mental health issues. His road to rehabilitation served as evidence of his fortitude, integrity, and commitment to aiding others. Williams' advocacy efforts and candor about his struggles have created a

lasting legacy that continues to uplift and encourage others going through comparable struggles. Even after his tragic passing, Robin Williams has had a significant influence on the fields of addiction treatment and mental health, guaranteeing that his bravery and compassion will be remembered for many years to come.

Chapter 6

Robin Williams's Community Impact and Charitable Efforts

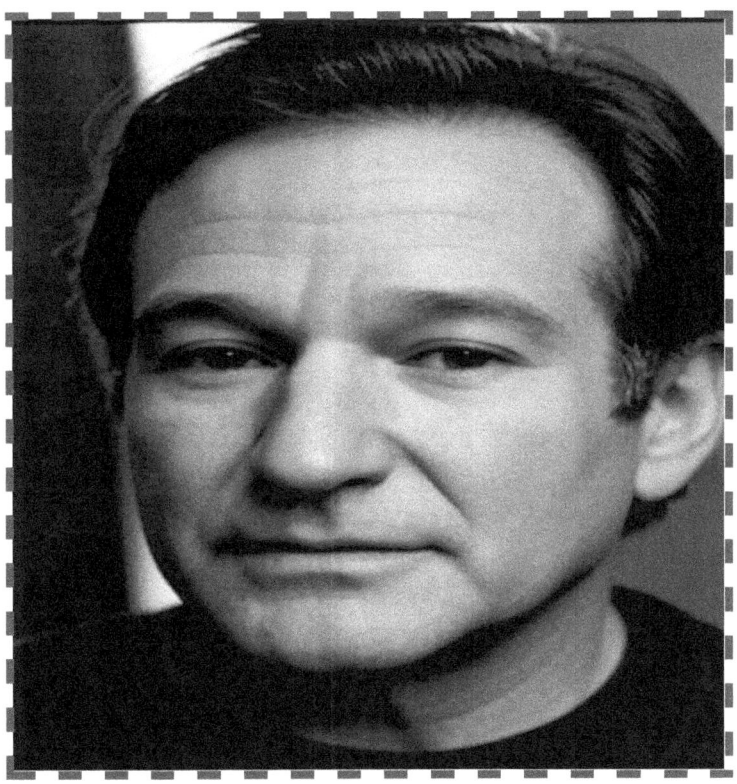

In his sojourn in life, Robin Williams who was well-known for his amazing skill and giving nature was actively engaged in several humanitarian endeavors. His strong sense of empathy and desire to change the world served as the driving forces behind his endeavors. An extensive examination of his philanthropic activities, his engagement in issues near and dear to his heart, and his noteworthy influence on the community is provided here.

1.) Comic Relief: Williams' involvement with Comic Relief, a nonprofit organization that aids the nation's homeless, was among his most notable and well-known humanitarian efforts. Billy Crystal, Whoopi Goldberg, and Robin Williams co-hosted the 1986 launch of Comic Relief. The occasion consisted of a sequence of televised fund-raisers that blended humor with requests for cash. Comic Relief has earned millions of dollars via fundraising efforts throughout the years, giving vital assistance

to homeless shelters, health treatment for the destitute, and other necessities.

2.) Intimacy with Self: Williams was heavily involved in the event's organization and execution in addition to serving as host. His sincere pleas and real care for the subject struck a chord with viewers, greatly influencing the success of the charity.

St. Jude Children's Research Institute, Inc.
Williams was a fervent advocate of St. Jude Children's Research Hospital, a facility devoted to treating and curing life-threatening illnesses in children.

3.) Advocacy and Fundraising: He took part in a lot of activities and fundraising efforts to help St. Jude's work. Williams' participation made it possible for the hospital to acquire funding and publicity, ensuring that all children, regardless of their family's financial situation, got the essential medical treatment.

4.) United Service Organizations, or USO): Williams entertained American soldiers stationed all around the globe as part of a long-standing association with the USO.

Acts and Guided Tours
Williams took part in USO tours for more than ten years, entertaining soldiers in far-off places and war zones. His presentations gave military personnel stationed far from home much-needed humor and a lift to their spirits. His dedication to these deployments proved how much he valued the

soldiers and how much he wanted to help them in difficult circumstances.

5.) The Foundation of Christopher and Dana Reeve: Actor Christopher Reeve was a personal friend of Williams, and after Reeve's accident, Williams enthusiastically embraced the Christopher & Dana Reeve Foundation in the following way;

> A) Backing for Research on Paralysis: Williams made a substantial contribution to the organization, which aims to heal spinal cord injuries and enhance the lives of those who are paralyzed. His assistance enabled the charity to carry out further research and provide assistance to those impacted by spinal cord injury.

6.) His Pivotal Roles in Eradicating Poverty: Williams has a special place in his heart for the problem of homelessness, partly because of his

involvement with Comic Relief. He often discussed the predicament of the homeless and the need to offer them resources and assistance.

7.) Public Advocacy: Williams urged the public and decision-makers to take action by using his position to advocate for homeless people. His kind demeanor and prominent position raised awareness of the problem and aided in promoting reform and funding for initiatives aimed at assisting the homeless.

8) Medical and Health Studies: Williams had a strong commitment to advancing medical and health studies, especially when it came to issues affecting his friends and family.

9) The Foundation for Cystic Fibrosis: He backed the Cystic Fibrosis Foundation, which raises money and awareness for the illness's research and treatment. Through his work, cystic fibrosis has

been better understood and managed, which has improved results for people who have the disease.

10.) Psychology: He was a vocal supporter of mental health care and awareness since he had publicly suffered from mental health difficulties.

11.) Personal Experiences and Advocacy: Williams' candor regarding his struggles with addiction and despair has contributed to a decrease in the stigma associated with mental health conditions. He promoted the value of mental health treatment and helped others by supporting several mental health organizations and projects.

Social Effects

12.) Participation in Local Community: Williams was well-known for his civic engagement and giving nature. He was known to often take part in neighborhood projects, support local charities,

and put on spontaneous performances at local establishments to generate money for different reasons.

13.) Participatory Support: His engagement at the grassroots level had a big influence, often bringing attention and funding to smaller issues and groups that they may not have otherwise gotten. Williams won over many people with his genuine care for his neighborhood and down-to-earth style, which positively impacted the lives of those he assisted.

14.) International Aid Activities: He supported international humanitarian activities in addition to his local and national contributions. He engaged in activities and initiatives that addressed global concerns including illness, poverty, and disaster assistance.

15.) Wide Influence and Reach: His international endeavors demonstrated his conviction that he should use his position to change the world for the better. Williams' participation in these causes contributed to raising awareness of and support for important problems impacting millions of people on a global scale.

A Legacy of Generosity and Compassion

Robin Williams left behind a legacy of deep kindness, giving, and a dedication to improving the world. Numerous people and communities have benefited from his long-lasting charity activities and engagement in numerous causes.

Model and Persistent Impact

Williams' commitment to charity serves as an example for others, encouraging them to help people in need. Through his efforts, he has powerfully shown how one person's compassion and giving can make a big impact.

In summary, Robin Williams demonstrated his great empathy and desire to assist others via his humanitarian endeavors and engagement in issues near and dear to his heart. Williams utilized his skills and abilities to make a significant difference in the world, from helping the homeless and medical research to promoting mental health and providing entertainment for the military. His giving attitude endures because of his legacy of compassion and generosity, which uplifts and benefits communities throughout.

Persistent Impact on Upcoming Performer Generations

Robin Williams has had a great impact and has left a lasting legacy for upcoming generations. We should learn from his kind gesture of heart in terms of generosity and his brilliant performance in Acting, he will continue to inspire generations to come. However, Robin Williams has impacted

upcoming performers to come in the following ways;

1.) Range and Versatility: Actors are still motivated by Robin Williams's ability to switch between humor and drama with ease. His portrayals are a master lesson in adaptability, inspiring upcoming actors to take on a broad variety of roles and genres.

2.) Dedication to Art: Actors want to emulate Williams' commitment to his parts, which span from serious tragedies to exuberant comedy. His unwavering work ethic and dedication to completely inhabiting his roles continue to set the standard for acting greatness.

3.) Impact on Comedy: His humor and improvisational abilities as a comic have endured. His impact may be seen in the work of modern

comedians, who are influenced by his impromptu approach and capacity for comedy in the ordinary.

4.) Empathy and Humanity: Williams' performances and personal life were replete with glimpses of his true humanity and compassion. Both artists and spectators are moved by his sensitivity and grasp of the human condition, which serves as a reminder of the healing and connecting potential of narrative.

5.) Openness and Advocacy: More honest discussions about mental health and addiction in the entertainment world have been made possible by Williams' transparency about his problems with these issues. His openness to talking about these problems in public has lowered stigma and raised awareness of mental health concerns by inspiring other entertainers to get care.

6.) Influence and Mentoring: Actors and comedians who have collaborated with Williams often talk about his guidance and compassion. His eagerness to help up-and-coming talent and his collaborative attitude have left a lasting impression on the business, encouraging mutual respect and a feeling of community.

Final Thoughts

In his final years, Robin Williams gave several outstanding performances that highlighted his range and complexity as an actor. New performers are influenced and motivated by his work, which carries on his legacy of brilliance, compassion, and humanity. Williams's energy and impact will continue long after his death because of his contributions to humor, movies, and humanitarian causes. His legacy will go on forever.

The Final Years

The Events Leading Up to Robin Williams' Untimely Death

With deepest Sadness in my heart, Robin Williams died untimely and it is uncalled for. We need to have a sober reflection of his life looking at the tremendous impact he had left to all and Sundry. Several and multiple factors lead to his premature death such as his heart issues, Robin Williams had several serious health issues in the years before his passing, which had a substantial impact on both his physical and emotional well-being.

Following his passing, it became clear that Williams had Lewy body dementia, a kind of degenerative dementia that impairs thinking, reasoning, and independent function. Visual hallucinations, sleep problems, and significant cognitive swings are common symptoms of this illness, which added to Williams' extreme misery in his last months.

Also, apart from health issues, In the early 2000s, Williams went back to abusing alcohol, even after twenty years of abstinence. By pursuing therapy, he demonstrated his ongoing dedication to becoming well. But he was burdened by the demands of his personal life, job, and health all at once.

The Last Day of His Life

Williams had symptoms of extreme melancholy and paranoia in the latter days of his life, which were made worse by an undetected Lewy body dementia. According to reports, he was agitated and nervous, suffering from sleeplessness and growing cognitive decline.

August 11, 2014

Robin Williams was discovered dead at his Paradise Cay, California, residence on August 11, 2014. He had committed suicide, according to the Marin County Sheriff's Office. Fans, friends, and family

throughout the globe were stunned and heartbroken to learn of his passing.

His untimely and terrible demise devastated his family and close friends. His children and wife, Susan Schneider Williams, conveyed their sorrow while underlining how much they loved him. Schneider Williams described her husband's death as a "terrible disease" and expressed her deep sadness in a public statement.

Friends' Statements
Steven Spielberg, Whoopi Goldberg, Billy Crystal, and other close friends and coworkers expressed their sadness and honored Williams' extraordinary brilliance and generosity. They brought to light his humor, compassion, and close relationships with everyone around him.

Public and Fans

The public's response to Williams' passing was one of astonishment and deep grief. Supporters everywhere lamented the passing of a legend who had made millions of people laugh and smile. Around the world, memorials and tributes began to appear, ranging from online tributes on social media platforms to improvised monuments at sites essential to his career, such as the "Mrs. Doubtfire" home in San Francisco.

Remembrances and Tributes

A plethora of public personalities and celebrities honored Williams by recounting their interactions with him and sharing tales of his compassion. In his tribute, prominent monuments like the Golden Gate Bridge and Broadway theaters turned down their lights.

Although the world mourned the sudden passing of Robin Williams, his legacy lives on thanks to his amazing body of work, charity efforts, and the

many lives he touched with his compassion, generosity, and humor. His energy and influence will be felt for many generations to come thanks to his ongoing inspiration and uplift in comedy, movies, and mental health awareness.

Chapter 7

Awards and Praise from Critics

Robin Williams' career was characterized by a broad spectrum of highly regarded performances in several genres, garnering him several plaudits, nominations, and awards. His range and depth as an actor were shown by his ability to switch between humor and drama with ease. Here is a thorough examination of the critical reactions to his work and the significant honors he was bestowed with during his career.

Oscars (Awards)
1. The 1987 film "Good Morning, Vietnam"
Suggested Role: Best Actor in a Leading Part
Details: Williams received his first Oscar nomination for his depiction of the energetic radio DJ Adrian Cronauer during the Vietnam War. His improvisational skills and capacity to inject comedy

into somber situations were on full display throughout the movie.

2. The 1989 film "Dead Poets Society"
Suggested Role: Best Actor in a Leading Part
Details: Williams received critical praise and his second Oscar nomination for his poignant portrayal of the inspiring English teacher John Keating. The movie became a cultural icon, praised for its examination of personal identity and the influence of schooling.

3. The 1991 film "The Fisher King"
Suggested Role: Best Actor in a Leading Part
Details: Williams received his third Oscar nomination for his portrayal of Parry, a destitute man searching for the Holy Grail. His acting versatility was shown by the way he matched sadness with humor in his performance.

4. The 1997 film "Good Will Hunting"

Award: Best Supporting Actor

Details: Williams' portrayal of Dr. Sean Maguire, a sympathetic therapist who assists a tormented genius, earned him his first and only Oscar. The performance was very poignant, demonstrating Williams' capacity to communicate great knowledge and humanity.

(Academy Awards)

1. The 1987 film "Good Morning, Vietnam"

Award: Best Actor in a Comedy or Musical Motion Picture

Details: Williams won his first Golden Globe for his upbeat and funny performance.

2. (1993) "Mrs. Doubtfire"

Award: Best Actor in a Comedy or Musical Motion Picture

Details: Williams plays Mrs. Hillard/Daniel Hillard. Doubtfire won another Golden Globe by showcasing his comic brilliance and adaptability.

3. The 1997 film "Good Will Hunting"

Nomination: Best Supporting Actor in a Motion Picture

Details: He was nominated for a Golden Globe for his highly lauded performance in this movie.

4. The 1991 film "The Fisher King"

Award: Best Actor in a Comedy or Musical Motion Picture

Details: Williams won a second Golden Globe for his performance in this exceptional fusion of humor and drama.

5. The 1998 film "Patch Adams"

Nomination: Best Actor in a Comedy or Musical Motion Picture

Details: He received another nomination for his depiction of a physician who heals people with comedy.

(Emmy Awards for Primetime)

1. The 1987 film "Carol, Carl, Whoopi, and Robin"
Award: Best Individual Performance in a Musical or Variety Show
Details: Williams received an Emmy for her work on this television program.

2. 1988's "ABC Presents: A Royal Gala"
Award: Best Individual Performance in a Musical or Variety Show
Details: Williams' performance on this unique occasion earned him another Emmy.

3. The 1997 film "Friends"
Award Nominee: Best Comedy Series Guest Actor
Details: He received an Emmy nomination for his noteworthy guest appearance on the well-liked comedy.

SAG Awards (Screen Actors Guild)

1. The 1997 film "Good Will Hunting"
Award: Male Actor in a Supporting Role with an Outstanding Performance
Details: Williams received praise from his colleagues for his moving portrayal of Dr. Sean Maguire.

(Awards for BAFTA)
1. The 1987 film "Good Morning, Vietnam"
Suggested Role: Best Actor in a Leading Part
Details: The British Academy of Film and Television Arts also honored him for his performance as Adrian Cronauer.

2. The 1997 film "Good Will Hunting"
Suggested Role: Best Supporting Actor
Details: He was nominated for a BAFTA for his critically praised role in this movie.

Additional Notable Awards

Grammy Awards

Williams' significance in the stand-up comedy scene is shown by the several Grammy Awards he received for his comedy albums.

1. The 1980 song "Reality... What a Concept"
Win: Best Comedy Recording

2. The 1988 film "A Night at the Met"
Win: Best Comedy Recording

3. The 1989 film "Good Morning, Vietnam"
Win: Best Recording of Comedy

4. The 2003 release of "Robin Williams - Live 2002"
Win: Album of Spoken Comedy

Invited Recognition

1. Becky. 2005 DeMille Award

Details: Williams received the Cecil B. DeMille Award for his exceptional achievements in the entertainment industry at the Golden Globe Awards.

2. Awards for American Comedy

Details: Throughout his career, Williams was recognized for his contributions to humor with several American Humor Awards.

3. Award Disney Legends (2009)

Details: Williams' legendary performance as the Genie in "Aladdin" earned him the title of Disney Legend.

4. Walk of Fame in Hollywood

Details: Williams' achievements in humor, television, and cinema were honored with a star on the Hollywood Walk of Fame.

Collaborations and Professional Relationships

Robin Williams collaborated with comedians, actors, and filmmakers on many noteworthy projects. These collaborations not only influenced his art but also brought to light his adaptability, originality, and close relationships he made in the entertainment sector. Here, we'll look at a few of the key business partnerships and alliances that shaped Williams' remarkable career.

Working Together with Directors

1.) Barry Levinson:
Williams' move from comedic to more serious parts was greatly aided by his partnership with Barry Levinson.

A. The 1987 film "Good Morning, Vietnam"
Details: Williams was allowed to demonstrate his improvisational abilities in a dramatic setting when

Levinson cast him as Adrian Cronauer. Williams received his first Academy Award nomination for the picture, which was a critical and financial hit and cemented his status as a gifted actor.

B. "Toys" (1992)**

Details: Despite not becoming as popular as their last project, "Toys" showed Williams' adaptability to play oddball and eccentric parts. Williams was able to develop a new kind of character in a visually striking picture thanks to Levinson's directing.

2.) Peter Weir

"Dead Poets Society," is one of Williams' most well-known movies, and was directed by Peter Weir.

A. The 1989 film "Dead Poets Society"

Details: Williams gave one of his most remarkable performances as John Keating under Weir's direction of this uplifting drama. Williams received a nomination for an Academy Award as a

consequence of the partnership, which produced a film hailed for its stirring message and depth of emotion.

3.) Gus Van Sant
Williams was helmed by Gus Van Sant in one of his most celebrated parts.

1. The 1997 film "Good Will Hunting"
Details: Williams had a very subtle performance as Dr. Sean Maguire thanks to Van Sant's directing in "Good Will Hunting". The popularity of the movie and Williams' Oscar-winning performance demonstrated his capacity to endear his characters to the viewer.

Working Together with Comedians
1.) Steve Martin:
Steve Martin and Williams had a great working relationship on "Waiting for Godot."

1. The 1988 film "Waiting for Godot"
Details: Williams and Martin played the key parts in Mike Nichols's staging of Samuel Beckett's play. The partnership was noteworthy because it brought together two of the most important comedians of their day for a highly regarded theatrical play.

2.) John Belushi:
Williams' early career was impacted by a noteworthy, but short, professional association with John Belushi.

1. "Mork & Mindy"
Details: Williams and Belushi's comic chemistry was on full display during their "Saturday Night Live" performance. Williams' early comic approach was shaped by their relationship and professional encounters, which were inspired by Belushi's audacious and uncontrolled comedy.

Robin Williams' career and legacy were greatly influenced by his professional connections and

partnerships with comedians, actors, and filmmakers. These collaborations brought out the best in Williams, enabling him to demonstrate his wide range of skills and make a lasting impression on the entertainment business. Williams' collaborations enhanced his performances and solidified his position as one of the most adored and varied performers of his time, showcasing his dramatic depth and improvisational brilliance.

Innovations and Contributions to Comedy

Robin Williams has made enormous and revolutionary contributions to comedy. His distinct approach, avant-garde methods, and unwavering inventiveness have made a lasting impression on the comedy scene. This is a comprehensive examination of his inventions and achievements in the comedy industry.

A.) **Distinctive Comedy Approach**

1. Quick-Fire Distribution: Williams was well known for his quick wit and lightning-fast ability to piece together observations, impressions, and jokes. His energetic and inventive performances had the crowd on the edge of their seats.

2. Character Development: He was unmatched in his ability to conjure up a vast assortment of personas on the fly. Williams' performances were lively and surprising due to his ability to move between voices, dialects, and characters with ease.

3. Intelligent Humor: He thrived on interaction, in contrast to many other stand-up comedians who follow a predetermined routine. He often interacted with the crowd directly, bringing their responses into his performance and fostering a special, interactive experience.

B.) Material Humor

1. Emotional Body Language: Williams' humor relied heavily on his body language. His performances were made funnier by his exaggerated facial emotions, dynamic gestures, and physical movements.

2. Staging and Motion: To improve his acts, he often incorporated mime and movement. He was able to bridge the gap between verbal and physical comedy with an ability to express humor just via his movements, evoking the spirit of silent cinema comedians.

C.) Advances in Unscripted Comedy

1. Combining Genres: Williams was skilled at incorporating many genres into his stand-up acts. He skillfully blended absurdist comedy, social criticism, and political satire to create a complex and broadly appealing work.

2. Adjustment: His ability to improvise raised the bar for stand-up comedy. Williams stood out from his contemporaries due to his ability to produce funny, impromptu stuff on the spot. This aptitude also impacted a great deal of other comedians.

D.) Innovating New Formats

1. Special TV Episodes: Williams' stand-up specials, including "Robin Williams: Live at the Met" (1986), established standards for broadcast comedic performances and introduced his skills to a wider audience. Millions of people saw his humor in these specials, which encapsulated the spirit of his live performances.

2. Technology Integration: He often included allusions to pop culture and modern technology in his acts, which gave his humor a contemporary feel. By using this strategy, he was able to keep his work relevant to audiences of all ages.

Finally, The comedic ideas and contributions made by Robin Williams were revolutionary and extensive. His distinct aesthetic, improvisational mastery and capacity to combine humor with genuine emotion revolutionized the comedy scene. Williams' influence on culture, the many comedians he influenced, and his iconic performances all contribute to his legacy. His output continues to serve as a tribute to the transformational potential of humor and the timeless attraction of a genuinely exceptional performer.

His Moral Principles And Philosophy

In addition to being a gifted comedian and multi-talented actor, Robin Williams had strong personal convictions, moral principles, and philosophical views that had a significant impact on both his personal and professional life. The following details provide some understanding of

Robin's principles, values, and personal convictions:

1. Empathy & Compassion: Robin Williams had faith in the efficacy of compassion and empathy. He had a deep comprehension of human emotions and the challenges that individuals encounter. Both on and off screen, he placed high importance on compassion and empathy. These attributes were often shown by his characters, and he was renowned for his sincere empathy for other people. Williams believed that to comprehend and relate to others, empathy was a must. He demonstrated his faith in the restorative power of laughing by often using comedy as a tool to encourage and console people.

2. Genuineness and Susceptibility: Robin Williams believed that vulnerability should be embraced and one should stay true to oneself. He believed that sincerity was essential to real human connection.

In both his personal and professional life, he valued sincerity and genuineness. He had no problem being vulnerable and sharing his troubles with the public. He believed that to develop and connect, one must embrace vulnerability. He often included personal anecdotes in his art to engage viewers more deeply.

3. Expression and Creativity: Robin Williams had faith in the ability to express oneself creatively and authentically. He considered art to be a tool for relating to people and investigating the human condition. Whether it was in comedy, acting, or other creative pursuits, he appreciated uniqueness and inventiveness in all kinds of expression. Williams thought that the human experience was fundamentally shaped by creativity. He urged people to follow their artistic instincts and be true to who they are.

4. Comedy as a Curative: Robin Williams thought that comedy could change people. He believed that laughing was a global language that could heal emotional scars and unite people. He saw comedy as a therapeutic and entertaining technique. He addressed tough subjects and offered solace from life's hardships by using his comic abilities. Williams thought that to keep perspective and have pleasure in life, one must laugh. He encouraged people to embrace comedy as a coping mechanism by using it himself.

5. Being Present-Moment: Robin Williams had the view that it is important to live in the present. He believed that life was made up of transient moments that should be treasured and relished. He aimed to completely participate in every moment and live life to the fullest, placing a high importance on mindfulness and the present. He advocated for people to appreciate and be grateful for each moment since he felt that it was all we had.

6. Promoting Mental Health Advocacy: Robin Williams felt that it was important to dispel the stigma associated with mental health conditions and increase public awareness of them. He understood that keeping quiet about mental health issues only served to reinforce stigma and loneliness, thus he valued candor and openness regarding these issues. Williams thought he could help break down barriers and build a more compassionate and understanding society by discussing his personal experiences and urging others to get treatment.

In summary, Robin Williams' life and work were profoundly influenced by his ideals, principles, and ideas. His genuineness, humor, and compassion have inspired and resonated with people all across the globe, leaving a legacy of empathy, kindness, and innovation.

Chapter 8

How Technology Has Affected His Career

Technology has had a profound effect on Robin Williams' career, influencing not just his comedic style but also his prominence in the entertainment sector. Here are some examples of how technology affected different facets of his career:

1. Production of Film and Television: As Williams' career grew, more inventiveness and visual effects became possible because of developments in television and film production technology.

He was able to work on more inventive and visually spectacular projects as a result, such as "Jumanji" (1995) and "Hook" (1991), where he collaborated with computer-generated imagery and fantasy settings.

2. Comedy Stand-Up: Stand-up comedy specials were made simpler to record and disseminate as home video technology advanced in the 1980s and 1990s. Through VHS cassettes and subsequent DVDs, Williams' stand-up specials, such as "Robin Williams: Live at the Met" (1986), were able to reach a larger audience, cementing his status as a legendary comedian.

3. Voice Acting: Williams and other voice actors have more options because of advancements in animation technology, especially in the field of computer-generated imagery (CGI).

Williams's legendary portrayal of the Genie in Disney's "Aladdin" (1992) demonstrated how technology may be used to give animated figures more personality and expressiveness.

4. Performance and Improvisation: Williams was able to explore and improve his performances because of the increased freedom that digital editing

technologies afforded during post-production. Williams was able to experiment with various humorous vantage points and improvise while shooting, secure in the knowledge that any errors could be polished or fixed after editing.

5. Fan interaction via social media: The way celebrities, like Williams, communicated with fans was altered by the emergence of social media platforms in the twenty-first century. Even though Williams' career began far before the social media era, his legacy is still strong online thanks to fan communities, memorial sites, and the sharing of his well-known performances. This shows how Williams' work has endured in the digital age.

6. Awareness of Addiction and Mental Health:
Online Resources: Thanks to technology, there is now easier access to resources and information on addiction and mental health.

Impact: Williams' battles with addiction and mental health in his final years were publicized and debated in media and internet forums, which reduced stigma and increased awareness of these problems.

All things considered, technology had a profound impact on Robin Williams' career, affecting everything from the making of his stand-up specials and movies to the way his legacy is honored and conserved in the digital era. Technology breakthroughs gave rise to new avenues for artistic expression, but they also presented difficulties and complications for Williams as he worked his way through the changing media and entertainment scene.

Conclusions and Reflections

The life of Robin Williams served as an example of the transformative power of genuineness, humor, and compassion. With his unmatched brilliance

and contagious charisma, Williams enthralled audiences with his stand-up comedy, film, and television appearances, as well as his early days. But in addition to his comic genius, Williams' path was characterized by deep reflection and emotional hardships.

He showed us the value of openness and asking for assistance when necessary through his battles with drugs and mental illness. He emphasized that it's OK to ask for help and that even those who make other people happy might be in misery themselves. Williams' influence goes much beyond theater and cinema. Millions are still inspired by his humanitarian endeavors, support of mental health awareness, and dedication to improving the world. He demonstrated to us the healing, uplifting, and unifying effects of laughter—even amid the most dire circumstances.

The memories he left behind, the lives he impacted, and the joy he provided to countless others are what will always remain evidence of Robin Williams' irreversible impact on the world. His timeless performances and the long-lasting effects of his generosity, imagination, and sensitivity are testaments to his spirit. As we consider his life, may we remember the teachings he imparted, which are to accept genuineness, practice compassion, and never undervalue the curative effects of laughter. In addition to being a comic genius, Robin Williams will always be regarded as a genuine lighthouse in a world in dire need of one.

Moral and practical implications of Robin's Story

The life story of Robin Williams is not just a story of comic brilliance and Hollywood success, but it is also a story full of moral teachings and life lessons that are relevant to individuals of all backgrounds.

The following are some important lessons that we might draw from Robin Williams' experience:

1. Accept Sincerity:

Lesson: The main factor in Robin Williams's attraction was his sincerity. He demonstrated to us the importance of being authentic—flaws and all—to find real joy and connection.

Key Takeaway: Accept and celebrate your individuality, frailties, and peculiarities. Being genuine fosters relationships and enables others to relate to you more deeply.

2. Develop Compassion:

Lesson: Williams showed a great deal of compassion for people all of his life. He taught us the value of compassion and empathy via his philanthropic efforts and his capacity for empathy with individuals from all walks of life.

Key Takeaway: Give others' experiences some thought and try to understand and sympathize with

them. Little acts of kindness may make a big difference in the lives of those around you.

3. Discover Comedy in Misery:

Lesson: Robin Williams used comedy as a coping strategy and a source of strength despite his challenges. He demonstrated to us the therapeutic and resiliency-boosting effects of laughing.

Takeaway: Acquire the ability to laugh at life's hardships. Laughing may make even the worst circumstances seem lighter and help us get through tough times.

4. Get Assistance When Needed:

Lesson: Williams' battles with mental illness and addiction serve as a reminder to us of the value of getting support when we need it. He demonstrated to us that being vulnerable is a strength rather than a flaw.

Key Takeaway: When you're having problems, don't be hesitant to ask for help. You're not alone in

your challenges, and it takes fortitude to seek assistance.

5. Treasure Your Relationships:

Lesson: Robin Williams placed a high priority on his friendships and family ties. He demonstrated to us the need to have deep relationships with others to be happy and fulfilled.

Key Takeaway: Give your loved ones top priority and schedule time for deep interactions. A fulfilling life is built on relationships.

6. Make a Good Influence:

Lesson: Robin Williams had a lasting impression on the globe via his activism, generosity, and the pleasure he provided to audiences everywhere.

Key Takeaway: Aim to have a little positive impact on the world before you leave it. Every person can positively impact the lives of others, whether via activism, artistic expression, or deeds of compassion.

Final Thought:
The life of Robin Williams is proof of the transformational potential of comedy, compassion, and truthfulness. In addition to his unforgettable performances, his legacy endures because of the lessons he taught and the people he impacted. We may pay tribute to his legacy and make an effort to lead more contented, caring lives by adopting his teachings.

Filmography of Robin Williams

Of course! The following is a complete list of Robin Williams's credits from movies, TV shows, and stage roles, including standout roles and cameos:

Cinematography Credits:
1. Adrian Cronauer, "Good Morning, Vietnam (1987)"
2. John Keating, "Dead Poets Society (1989)"
3. "Dr. Malcolm Sayer's Awakenings (1990)"

4. Parry, "The Fisher King (1991)"
5. "Peter Banning / Peter Pan - Hook (1991)"
6. "Aladdin (1992)" - Voice of Genie
7. "Mrs. Doubtfire (1993)" - Euphegenia Doubtfire / Daniel Hillard
8. Alan Parrish, "Jumanji (1995)"
9. Armand Goldman, "The Birdcage (1996)"
10. "Sean Maguire, Good Will Hunting (1997)"
11. Philip Brainard, "Flubber (1997)"
12. Patch Adams, "Patch Adams (1998)"
13. Chris Nielsen, "What Dreams May Come (1998)"
14. "The Insomnia of Walter Finch (2002)"
15. "An Evening Picture from 2002" - Seymour Parrish
16. "Smoochy's Death (2002)" - Rainbow Randolph
17. Bob Munro, "RV (2006)"
18. "Museum Night (2006)" - Theodore Roosevelt
19. Maxwell "Wizard" Wallace in "August Rush (2007)"

20. "Happy Feet (2006)" - Voices of Ramon and Lovelace
21. Lance Clayton, "World's Greatest Dad (2009)"
22. Theodore Roosevelt, "Night at the Museum: Battle of the Smithsonian (2009)"
23. "Happy Feet Two (2011)" - Voices of Ramon and Lovelace
24. "Dwight D. Eisenhower, The Butler (2013)"

Credits for Television:

1. Mork in "Mork & Mindy (1978–1982)"
2. Tomas / Thomas from "Friends (1997)"
3. "Robert Ellison, Homicide: Life on the Street (1994)"
4. Merritt Rook from Law & Order: Special Victims Unit (2008)
5. Simon Roberts' "The Crazy Ones (2013-2014)"

Credits at the Stage:

1. "Godot is Waiting (Godot is Waiting)"
2. "The Baghdad Zoo's Bengal Tiger (Bengal Tiger at the Baghdad Zoo)"
3. "The Opera of Three Pennies (The Opera of Three Pennies)"
4. Stand-up comedy special "Robin Williams: Live at the Met (1986)"

Notable Appears:

1. "Shakes the Clown (1991)" - Teacher Mime
2. Leslie Zevo, "Toys (1992)" (uncredited)
3. "A.I. Dr. Know, "Artificial Intelligence (2001)," voice
4. "Happy Feet (2006)" - Voices of Ramon and Lovelace

In Conclusion, Over many decades, Robin Williams' extensive career in theater, television, and movies demonstrated his extraordinary range as an actor and performer. Williams' performances

continue to enthrall and inspire audiences worldwide, whether they are in classic major parts or unforgettable cameos. His everlasting contributions to the entertainment industry ensure that his legacy endures.

www.ingramcontent.com/pod-product-compliance
Lightning Source LLC
Chambersburg PA
CBHW071931210526
45479CB00002B/631